ArtCare
Bridge to Hope

BY LAURA BRUNETTI

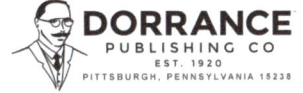

The contents of this work, including, but not limited to, the accuracy of events, people, and places depicted; opinions expressed; permission to use previously published materials included; and any advice given or actions advocated are solely the responsibility of the author, who assumes all liability for said work and indemnifies the publisher against any claims stemming from publication of the work.

All Rights Reserved
Copyright © 2021 by Laura Brunetti

No part of this book may be reproduced or transmitted, downloaded, distributed, reverse engineered, or stored in or introduced into any information storage and retrieval system, in any form or by any means, including photocopying and recording, whether electronic or mechanical, now known or hereinafter invented without permission in writing from the publisher.

Dorrance Publishing Co
585 Alpha Drive
Pittsburgh, PA 15238
Visit our website at *www.dorrancebookstore.com*

ISBN: 978-1-6480-4622-3
eISBN: 978-1-6480-4572-1

Contents

A Note From The Author . v

1. What Is Artcare? . 1
2. Looking Within: Artcare For Seniors, Alzheimer's
 Patients, And Brain Trauma . 7
3. The Caring Canvas: Artcare For Children 13
4. Boots On American Soil—
 The Creative Force: Artcare For Veterans 17
5. Behind The Mask Of Mental Illness 21

Acknowledgments . 25

About the Author . 29

"I am on a mission with God's permission."

—*Laura Brunetti*

A Note from the Author

"My number-one reason for creating is to help others."
—Laura Brunetti

My great-grandfather, the Reverend Paul Louis Buffa, was a descendant of a long line of pastors from Torino, Italy. He was an educated man, with degrees from many universities, including the University of Padua, the Sorbonne, the Calvinist University in Holland, and in 1917 he was a Dr. of Divinity at Colgate University. In 1919, after developing a tent city in New York with a group of his friends, he established the Church of St. John the Baptist on Lorillard Place in the Bronx near Author Avenue, known for its Italian restaurants, butchers, bakeries and food stores. There, he dedicated his life to God and to helping others.

I never met my great-grandfather, but I feel his spirit in everything I do. In his spirit, I've dedicated my life to utilizing everything I've learned and everything I have for the goal of helping others.

I was born in the Inwood section of New York, and attended Good Shepherd Catholic School. We moved to New Jersey in 1968 and there I sold my first sculpture at the age of eight at a street fair in Maywood, New Jersey. But my involvement with art as a child was limited to summer park programs. In 1982, I enrolled in Bergen Community College and completed an Associate's Degree in Behavioral Science while also working full-time. In 1988, I earned my Bachelor of Science in Business Administration and Marketing from Monmouth College, Monmouth University.

When I was in my early twenties, I spiraled into a severe depression. In retrospect, this experience turned out to be a crucial, positive turning point in my life. I had been hospitalized, and the hospital had an occupational therapy program, which included art. I still remember the string art piece that I made there, with shades of purple and an intricate design. It wasn't anything special, but it became for me a symbol of hope. It had revealed to me an unexpected and joyous path toward healing through art.

I took a break from art, knowing how important it was, but not knowing how to utilize that knowledge. But then, in my forties, on a whim, I registered for a watercolor and hiking outing while on a vacation. The instructor gave a quick demo, and then we hiked to a mansion with spectacular views. We completed our paintings and then hiked back. That evening, my instructor presented me with my painting, matted. I was so proud. I felt as though it was something I had birthed. It was in that moment that I became sure that somehow, nature and art would become an important soul-soothing part of my life.

When I returned home, I joined Marjorie Fister's painting group at The Art Alliance in Red Bank, New Jersey. Marjorie was a well-known and respected artist. The group had been painting for years, but they welcomed me, a beginner, with open arms. Marjorie became like a mentor to me. She encouraged me to be free, to paint right off the paper, as if the scene were continuing into infinity. Also, she taught me to never discard art that I didn't feel was worthy. During this period, I was painting two large watercolors a week. I soon set up a studio space in a beautiful wooded area with a pond. This space was very conducive to creativity and imagination and I was able to produce a lot of art. At my first group art show at the Colts Neck Library in New Jersey, I sold my first piece as an adult. It was a very large watercolor of a garden that I had painted with my Friday group.

I was happy about this, but still didn't feel fulfilled. I felt a calling to share the power I'd found in art with others. To this end, I opened a no-cost art studio for at-risk children. Students came from The Collier School, the Kateri Day Camp in Wickatunk, New Jersey, and the Mercy Center in Asbury Park, New Jersey. I arranged free transportation and supplies for them. Each room in the studio was painted a different color to inspire them. There were no worries of paint on the floor or on their clothing as I provided large dress shirts

that they wore as smocks. Those who wanted to decorated their smocks and kept them. It was an attitude of gratitude and giving.

There were two specific incidents at the studio that truly touched my heart. The first was a ten-year-old girl who was disrespectful to her mother who was chaperoning the children. I spoke to her mother privately, and she told me that her daughter didn't even have a mattress. I told the mother that I would have one delivered, but to not let her daughter know it was from me. The next week, I asked the children to dip their hands in a bowl of salt and to wipe away all the negativity before entering the studio. The little girl asked me if this was because of her behavior last week. I said, "No, it was for all of us. We all have bad thoughts sometimes, and this way we can all be ready to focus on creating."

Another day, three boys were painting in the meditation room, which was shades of restful green. One boy was doing an unbelievable drawing/painting of an African tribal girl dancing. I complimented him and he replied, "That's me, Miss Laura." I said, "That's wonderful." He gave me the painting to exhibit in an art show for The Caring Canvas™ at The Brownstone Experience in the East Village in New York City.

This period reinforced my belief that art could play a role in healing and could be a vehicle to express underlying desires we weren't yet ready to come to terms with in our lives. My approach to art was not to teach technique, but rather to encourage creativity and guide artists through expressing emotions in an open, accepting environment. My stress was always on the function of art as a powerful way to help with healing, for myself and for others.

I knew that from now on, my life would be dedicated to spreading this message of hope, love, and healing—through art.

"Laura Brunetti has combined her passion for art and her passion for 'sharing the health' of art with ArtCare. The process of art is truly healing. Art requires no training—just an open mind."

—Mona DiPasquale
Artistic Director, Autism Speaks

1
What Is Artcare?

"I met Laura Brunetti at a Prevention First fundraiser and she immediately struck me as someone who makes things happen. I would learn in the coming months and years how dedicated she is to fulfilling her life's mission of reaching out to those in need. I have watched her utilize her artistic talents working with at-risk children in different settings. Furthermore, Laura's commitment to raising mental health awareness is as inspirational as being a part of it and watching first-hand."

*—J Rajiv Juneja, M.D., M.S.,
Adult Psychiatry, Addiction Medicine*

In 2006, I received a call that my friend's mother, Hope (not her real name), was now living out her life in a nursing home. I didn't have much experience in nursing homes. I had sung in them sometimes as a child with the Girl Scouts or visited an elderly aunt. Thus, when I went to visit Hope, I didn't know what to expect.

Hope was confined to a wheelchair. She was diagnosed with Alzheimer's disease and was completely nonverbal. The floor Hope was on was designed specifically for those with Alzheimer's and similar conditions. I was overwhelmed with sadness when I entered the activity room. It was not at all what I had expected. I remembered with fondness the occupational therapy room I had experienced in the Englewood Hospital in New Jersey, where I had re-

covered from my mental health crisis in 1982. That place had saved my life. But now, as I scanned the room before me, it hurt to see human beings just existing. Yes, there were some puzzles or decks of cards, but not enough. Knowing what I had needed to emerge from my depression, I just knew I had to do more for these people. I wanted to engage the residents immediately. But first, I had to present my idea to the recreation director.

Unrehearsed, but full of passion, I introduced myself. "Hi, I am Laura Brunetti. I am an artist and a servant of The Most High Jesus Christ. I would like to have a painting workshop for a group of patients on this floor, in this room. I will put up an art show of my work and engage the residents in creating with watercolor paint."

The director said, without much enthusiasm, "You can try."

She doubted that the residents would do anything, but I had total faith. I returned the next week, loading the elevator several times and placing my art around the room on easels to inspire the residents. I set up a table for twelve with paint supplies, brushes, and Arches 140 watercolor paper. It was the same excellent-quality paper, paints, and brushes that I used for my art. I did that because their masterpieces deserved to last, and they wouldn't with inferior materials. I decorated the middle of the table with a metal, brightly colored butterfly, and I hung large fabric butterflies from the ceiling. I explained, knowing not all would understand, that each person would be painting the wing of a butterfly.

Most were at ease painting, others needed me to hold their hands to build confidence. Being surrounded by my colorful paintings and the hanging butterflies, they enjoyed the session. As they were finishing up, I took it one step further, asking if they could sign or print their names on their wing. A few were able to sign, print, or just do their initials. I had planned to return the next week and attach the wings to make them into butterflies. But when I came back, to my amazement, the nurses had already matted their creations. Hope and the other patients moved straight towards their own paintings with smiles, recognition, and delight. I could see in Hope's eyes that she knew she had birthed her piece of art.

This was my proof that art was, once again, an excellent vehicle to help those in need. I continued to volunteer at that facility for the next three years. Thus, ArtCare™ was born.

Always experimenting in order to find what worked best, I began to use black-and-white templates of my paintings, encouraging the residents to personalize the template utilizing their own colors and ideas. A favorite template was The Cozy Cottage, a template of a colorful watercolor I had painted. Everywhere I went, the participation was amazing. We were able to engage those who couldn't see by describing the scene. Those who were paralyzed chose their colors for others to paint with. The groups often named their cottages and the staff would frame them. We'd end the sessions by gathering to enjoy sparkling cider and a singalong with their families.

My goal was to make ArtCare a system and a philosophy that could be done with or without my presence. No art training was needed. ArtCare could be used anywhere, anytime, by anyone.

> *Welcome!*
> *When thoughts are difficult to grasp, and it's hard to recall the past, give them tools enveloped with love, prance around the table, hover like a dove! Art can relax minds to express freely. Paint with or without the Cozy Cottage guide provided with ARTCARE™. Remember, there are NO mistakes in art. Most can fully participate. Others can do what they can by offering color choices or a description of the Cozy Cottage. I know what they have inside, we just have to make their right brain decide. When you approach art, it's okay to touch hands — your energy will be received. Even those who may not speak can listen and feel your vibration. In some cases, the least responsive have responded through their project in wonderful ways! You can segue from art into a dress-up and singing session with props. (I encourage everyone to belt out a song!) Many can recall "Happy Birthday." "God Bless America" is another song proudly joined in on.*
>
> —*Laura Brunetti, ArtCare Welcome Letter*

I didn't realize the importance of singing to ArtCare™ until I worked with a young man I'll call JC. He had recently undergone a traumatic brain injury, leaving him to deal with paralysis and aphasia, the loss of the ability to understand or express speech due to brain trauma. Knowing I was an artist and had worked with patients with mental illness and cancer in various severities, his parents asked me to use my knowledge in hopes to engage him in art to evaluate his degree of understanding and communication. I brought The Caring Canvas activity book, with templates of my art in black and white. I also brought a musical globe with one of his favorite groups, KC and the Sunshine Band, and a bright yellow fabric butterfly to hang over his bed. I also had Sharpie markers and a metal pizza pan with magnetic letters.

Since I had known the family for several years and they knew of The Caring Canvas™, they immediately cleared me for visitation as a family member. With help from his brother we set up the room. When we put on the musical globe, JC tried to smile. I talked to him about an upcoming comic show, of which he was a big fan. I then placed an "infinity angel," which was an angel with the number eight as a body. I held his hand and we both colored it in orange. I still wasn't sure if he was mentally grasping it, but I placed another angel in front of him, and he colored it on his own. I realized this one didn't have an eight, so I said, "JC, draw a quick eight."

He did!

His brother called in his mom and dad. They were overjoyed. They messaged me that evening that they had decided to have JC undergo aggressive therapy. I researched aphasia and went to his speech therapy with him when I could. First, we practiced sounds. Little by little, he was able to blurt out a word. I kept track of his progress on index cards, which proved to be very important: If he said it once, he could say it again. Since it was the Christmas season, I decided to sing "Jingle Bells" to him. To my joy, he joined in. I'd learned through my research that singing and speech are driven by different parts of the brain, so song was a wonderful way to reach him.

We worked with magnetic letters, and eventually, he spelled words on the metal pizza pan. We practiced holding a cup with one hand or opening milk and juice containers. Before long, we graduated to buttons and zippers, practicing on Melissa and Doug learning toys. We went food shopping in the Publix Grocery Store Newspaper. I also cut out his favorite sports players and

he glued them to make a collage to hang in his room. Art had become a favorite activity.

JC was eventually transferred into a long-term rehabilitation center, so I returned to New Jersey to help my mother and father who were suffering, my father from Alzheimer's and Parkinson's and my mother from dementia and a rare form of leukemia. While there, I ran into a friend who was a Vietnam vet. I updated him on my artistic pursuits and the founding of The Caring Canvas™ and ArtCare™. We both agreed that a Veterans Division of The Caring Canvas™ was a must. We coined the name, Boots on American Soil—The Creative Force.

We had everything in place and were ready to move forward.

> *The Caring Canvas™ travels with EMPATHY and kindness. It approaches art as a vehicle to help one cope from everything from Post-Traumatic Stress Disorder (PTSD) to depression to brain trauma and autism. From this caring approach, ArtCare™ was born. Initially, intended for Alzheimer's patients, the modality is now utilized in workshops with others suffering physically or mentally.*
>
> *—Laura Brunetti*

Laura Brunetti

2

Looking Within:
Artcare for Seniors, Alzheimer's Patients, and Brain Trauma

In February of 2008, Laura touched the hearts of many patients and residents at the Care One Rehabilitation Center in Holmdel, New Jersey — including my father and hero, Bud Shapiro. My father, a loving man and devoted grandfather to his six grandchildren, gave his heart and soul to his family. We were devastated to discover he had brain tumors, leaving him paralyzed on his right side. Laura came to visit one evening at Care One and created an art show for the residents. She filled the social room with art supplies, cookies, and music. Laura cheered the residents on as she taught them how to paint Cozy Cottages, butterflies, and sweet memories. While my father was unable to hold a paintbrush, he still participated and watched as we danced and sang around him in the room full of original artwork. I was blessed to have my father meet Laura. That day will always be a sweet memory for me. He passed away September 19th, 2008. Thank you, Laura, for not only touching my father's heart, but touching the lives of everyone in that room and creating an art oasis full of hope.

With much love and appreciation,
Susan Belfer, Belfer Communications

One day, on my way to the nursing home, I realized I had forgotten my paints. I would have to improvise. I had small, stationery-size paper, pens, and ribbons to decorate with. I decided that on this day, we would write and decorate letters. Safe to say, the group hadn't written a letter since they were admitted to their floor, and they excitedly took on this project. Most wrote in cursive—like skipping instead of walking! I realized that they didn't fear change; they were happy to be engaged. Some of their family members had no idea to whom their loved ones were writing. It could have been a childhood sweetheart, a friend that moved away, or even a letter to themselves. It didn't matter. What was important was that we had sparked a memory and facilitated a connection. Art was in all things—painting, drawing, writing, music.

One year during the week of Valentine's Day, I took the Caring Canvas™ along with an Elvis impersonator to several nursing homes. At our first location, we set up long tables with soup-to-nuts of Valentine's Day craft materials. We had the Cozy Cottage templates along with handheld bells, tambourines, and shakers. The residents sang with Elvis, and some even danced with him. They gleefully took on the multi-task challenge. The daughter of one of the women brought her little service dog. I had jackets made with my art on the back, so I didn't have to carry framed paintings any longer. It was a magical, important connection that we all formed that day.

I knew that I wasn't doing this on my own. The key to getting through to people, even if they are challenged mentally or physically, is the love and light of Jesus Christ, which I share, and he replenishes. God blessed me with my artistic ability, and I am able to utilize it in serving Him. If others have other Gods, or no God at all, they still can feel and receive my love and kindness. It doesn't matter to me what others believe in; I'm at home with all kinds of people and my aim is to create an environment of love and acceptance for all.

Another key to getting through to people is forgiveness. Many families have issues with their family members, but at the end of someone's life, it is critical that the family stick together. It is imperative to love your loved ones unconditionally, especially in their time of need. The families I have seen come together over art, song, writing, and dance have been inspiring. It's all about being open to the change in those we love. The parent or spouse before you now in a nursing home or hospital isn't just the printer or doctor or whatever

distinguished your loved one before, the person you used to know. There is something else inside them which is all about the heart. That is the person whom you need to reach and to nurture. You must forgive them for no longer being who they were and accept them as they are now. People don't want to believe that there can be change, and they get mad and criticize. I can't tell you how many times a family member has said to me, "He won't paint" or "She won't sing." They are almost always amazed at what is hidden inside.

It is all about love and acceptance. We all know what it feels like to struggle. We are all driven by pain, emotion, and joy. Early in my journey, with the ups and downs of mental illness, when I was blessed to spend time as a patient, I met people from all walks of life who were facing many different challenges. One patient I remember was a cartoonist, and despite his severe depression, he was able to share his work with us, the other patients. I, on the other hand, had been so zipped shut emotionally, I wasn't even able share that I was an artist. The state of mind I was in was terrible. I barely spoke. I was paranoid and unable to eat. Yet the staff was so kind and loving. I remember one particular nurse would visit me at night and tell me how she went into a severe depression after being in a serious auto accident. She gave me a glimmer of hope, seeing her positive attitude and recovery. There was also a male nurse would bring me my medicine and chat awhile. Love is all you need, but I am also a firm believer in medication. It worked for me more than once. But what is most important is that you always, always recognize that there is a human being inside the frozen shell of mental illness. Kindness, love, and acceptance are felt, even if not responded to.

One must also have love, kindness, and respect for themselves. In 2004, I realized I would have to take medicine for the rest of my life. Without it, I could spiral into a severe depression, and maybe even attempt to take my life. There is no side-effect any worse than that. Loving friends thinking they were speaking in my best interest would tell me that I needed to get off the medication. At one point, I visited Dr. Joel Furhman, who was trained as a medical doctor and practiced holistic medicine. He gave me an option of supplements and vegetables, but that would only lower me one pill a day. He said that with my history of a suicide attempt, severe depression, and suicidal ideology, the medication was still needed. He was so helpful and empathetic. And he was accepting and loving toward the me who needed his help. In this way, the circle is completed—I am healed so that I can then heal others.

I have been blessed along the way with so many strangers who helped me without judgment and expected nothing in return. I can't leave out my friends, family, and husband at the time, who were a great help to me. My Friday afternoon painting group was also very supportive. After my depression, I found out that several of the women in the group had also gone through postpartum depression. The understanding and empathy was there. We just had to all open up and reach out. This is always the path toward healing.

Prior to being hospitalized for the third time in 2004, I painted while severely depressed and while enduring the side-effects of the medications we were experimenting with. One of the worst side-effects for me was the sensation that my skin was crawling inside and out. I made it to the Friday painting group, so I was determined to paint through it. I painted a vase, flowers, a rainbow of colors, and with my brush, the words appeared: *When my head is spinning and I am feeling blue, I pick up my brush and let the colors shine through.*

It was amazing that all of my paintings during my depressions were all so colorful and uplifting, not depicting the struggle I endured, but rather the hope within. Only by looking within can we create art from the heart. One way I look within is by reviewing artwork I've done over the years. I look over my art, my journals, and what I call my sketch journals. I found that my sketch journals were much more powerful emotionally than anything else I'd done. I could close my eyes and visualize the location where they were sketched and feel myself transported there.

Art from the heart is particularly powerful when including other senses. The sense of smell is incredibly important for emotional memory recollection. For example, a perfume or cologne can link you back to a person, or the scent of cooking can make you recall a holiday meal. The brain may be dormant in some areas but engaging the person with all the senses will bring them back by evoking a different kind of emotional response. This is why I always try, especially with seniors, to employ every method I can to awaken their memories and their joy.

The senior groups that I have worked with outside of nursing home setting are often anxious to participate in art. It's crucial to create non-threatening ways to be creative. Many people are just not comfortable with art. One group I volunteered with during Saint Patrick's Day was entertained by a wonderful singer of Irish music. I engaged many of them to join me on the dance floor. We

played Pass-the-Shamrock, which meant that when the music stopped, the person with the shamrock had to paint something onto the large canvas on the easel in the front of the room. This eliminated the fear of creating an original work of their own, and also laid the groundwork for future painting activities.

> *"A Monmouth University graduate with a degree in Marketing, Brunetti is a world-class healing artist: She creates customized artwork for individuals dealing with the pain of disease or loss, frequently donates time in her Colts Neck studio for lessons, and raises funds for charities with her vibrant paintings."*
>
> —*Monmouth Health and Life Magazine,*
> *May 2008*

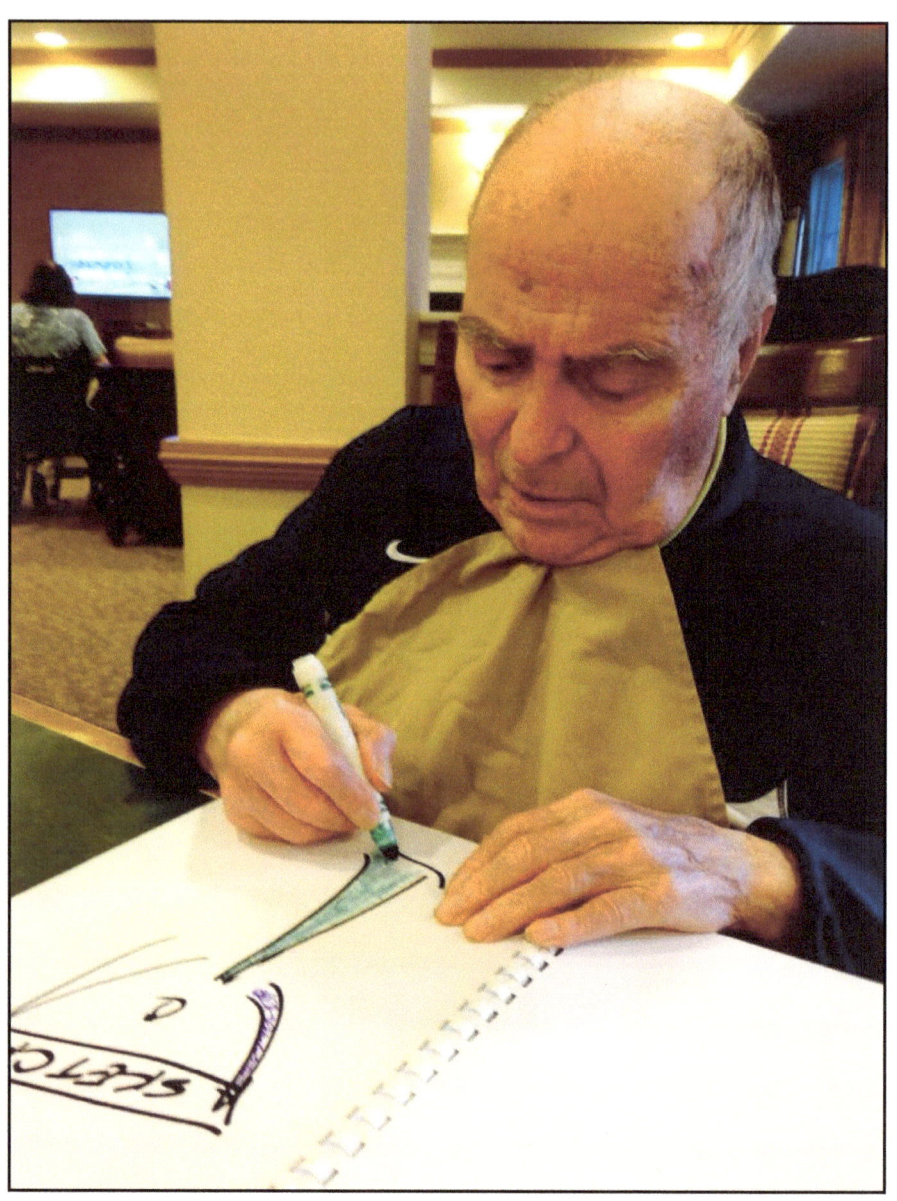

Dad Paul Buffa (RIP) agreed to participate with the others at the facility.

3
THE CARING CANVAS:
ARTCARE FOR CHILDREN

"Laura gives generously of her talents, resources, and time to make life better for the less fortunate. Her zest for life, her willingness to give of herself, and her philanthropic spirit are contagious and rally others to the charities she believes in. A dynamo on the go, Laura's guardian angels must fly as fast as they can to keep up with her!"

—Jacki St. Angel, Collier Services.

My journey to helping others through art began with my desire to bring art to children in need. The Caring Canvas™ is a canvas of faith, opening doors for all children to participate, no matter their needs. For example, in the summer of 2012, The Caring Canvas™ provided a day of art, dancing, and singing with the band New Life Crisis at Alternatives for Children, in South Hampton, New York. Collectively, we came up with the idea of providing a large, blank, un-stretched canvas. The children would dip their hands in various colored, nontoxic paints, and make their mark. It was an excellent way for all to participate. The children were so excited, and the parents were thrilled. This event wouldn't have been possible without the help of Eva Belfer, the Junior Ambassador of The Caring Canvas, her mother Susan and Kathleen Turner.

Afterwards, we took this canvas of joy to the Dominican Republic, where it was used for inspiration. Susan Belfer, Roger Crazy Wolf (LoBo Loco) and Be Scene Photography were instrumental in sharing the Art from the Heart. Later it was made into pillows for a fundraising event. I went to the Dominican

Republic with a group from Florida, *Ninos en Action 501c3, founded by Zoe Prieto*, Hialeah, Florida. We traveled to a small village that was very poor. We did art with over two hundred children there. They were so happy we had come. They took us to their homes to show us how they lived. They lived very simply: one shared bed, their water supply in a large drum, their cooking done over coals outside. The most important thing I noticed written on the wall: Dios Amor, *God is Love*. They had all that they needed.

Another important children's project I ran for many years was The Caring Canvas™ Camp in The Asbury Park Transportation Center, a program that was funded by The Caring Canvas and Monmouth Cares. They provided children from their program, and I engaged the children from the westside of Asbury Park. This was a no-cost program. The children there were so excited about making art and being together. I gave them food—usually hotdogs and occasional pizza parties—and provided art supplies. That was all we needed. The kids did all the work.

When working with children, I made it a point to always have one art exercise about feelings. One project that worked well was when I had the children section off a large piece of construction paper and told them to draw a different feeling in each box. I asked them to focus on something that had happened to them. I knew that learning to express emotions in a positive way at a young age would help in their family dynamics and future relationships, especially when they began to work or volunteer. I used this exercise to teach them about public speaking also. After they had all spoken about their work, I asked them to forgive anyone in the group with whom they had encountered a problem. We sat in a circle and ironed out our differences. I taught them that forgiveness, if not given, is an emotional weight carried by the victim. That is, the person who was hurt carries the burden. It is so important to let that weight go.

Another aspect of caring I incorporated into the camp was The Gratitude Circle. It was created initially to gather the children at camp in an orderly fashion. Sitting in a circle, I learned, creates an environment where the children feel safe, so they are able to open up. Every day, we each wrote a Gratitude List, and then we explained it to the others.

We also drew angels in the Gratitude Circle, a wonderful thing to be grateful for. The next day, I would give the children the opportunity to draw

and paint large angels. We hung up the angels, and I gave each child a different bag with Hope, Love, Create, and other positive words. Then we danced to my favorite disco music. The children just loved seeing me dance, and they loved to copy. It probably didn't hurt that at 4'11", we were all about the same height! In no time, we were all chanting, *"Gratitude Is the Attitude."*

I had stickers printed for them with those words, to remind them of the joy and togetherness we had created.

> *"WHEREAS: Laura Brunetti, founder and owner of L'Estrella Studio in Colts Neck, New Jersey, is a unique humanitarian... began...serving with many not-for-profit organizations, utilizing her artistic abilities to better serve the communities around her and WHEREAS, Laura Brunetti has been honored with many community awards... and has also been an active auxiliary member of the Children of the Marian Center...and an active volunteer for the Girl Scout Council...and has turned her artistic endeavors into the art of giving, allowing private clients to purchase her original artwork and write their checks directly to their chosen not-for-profit organizations... and after 15 years of collecting and creating art programs and exhibits for at-risk youth and mental health consumers to mentor, inspire, and give hope through artistic expression, NOW THEREFORE, BE IT RESPECTFULLY PROCLAIMED, that Laura Brunetti is commended and honored for her dedicated service and commitment to the youth and communities of Florida."*
>
> *—Eduardo (Eddie) Gonzalez,*
> *Representative, District 102,*
> *House of Representatives, Florida*

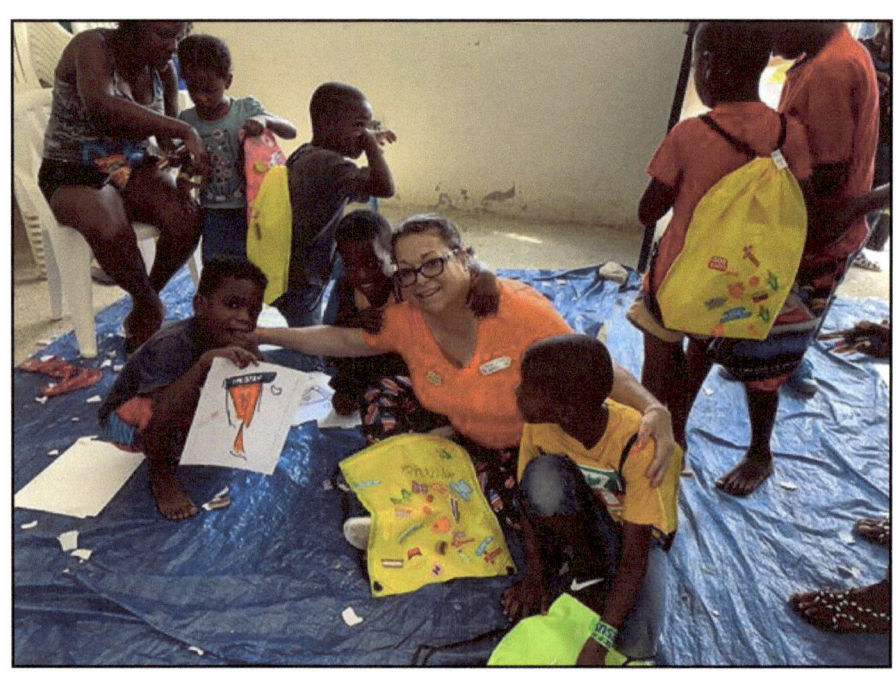

Laura Brunetti sharing her Angels and backpacks and shirts to paint. J. June 2019, Dominican Republic, small church in the country.

4
BOOTS ON AMERICAN SOIL—THE CREATIVE FORCE: ARTCARE FOR VETERANS

Boots on American Soil is the Veterans Division of The Caring Canvas™ — The Creative Force. Offering no-cost workshops for those suffering from Post-Traumatic Stress Disorder, it utilizes art as a vehicle for coping.

Boots on American Soil,
Founder/Director/Producer/Artist,
Laura Brunetti

We had just formed the idea for Boots on American Soil—the Creative Force, but hadn't publicized anything yet, when I received a call from a woman I had served with on the board of The Mental Health Association of Monmouth County.

She said, "I know it's last minute, but the Marine commander is visiting with a local veteran, who happens to be a military artist. Can you be there at three?"

I said, "Absolutely!" I was thrilled!

When I entered the studio of Wally Zuber, a Marine veteran, I knew my first mission was to create an atmosphere conducive to laughter and joy in order to offset pending tears. His watercolors were emotion-provoking and precise. We agreed that afternoon that he would paint one of his combat boots to become our mascot for Boots on American Soil—The Creative Force.

So much happened as if it was meant to be. I was in New Jersey for only a short time, so I joined Faith Fitness for three months, where I met a trainer who was retired Air Force. We discussed having an event that included his work, as he had taken up art after retiring from the Air Force as well as being

a fitness trainer. His wife was also an artist, and I told him that we could include her in our non-military shows. I also told him about Marine veteran Wally Zuber, who was a founding veteran of the Caring Canvas.

On the day of the event, the activity was nonstop. The interest and need to talk was beyond belief. Veterans volunteered to donate their medals, patches, and parts of their uniforms to use for collage and in paintings. I stayed, listened, wiped tears, and offered literature about Post-Traumatic Stress Disorder (PTSD). I was not only speaking to veterans and their families, but also to parents of children with mental illness and others who were there.

One staff member, never in the military, showed me his artwork—pencil drawings, deep, dark, and depressing. He opened up to tell me that he was whipped by his mother for being homosexual. He showed me his shoulders. The scars were horrific. I could only imagine the rest of his back. We exchanged numbers and I invited him and his friend to an art show.

I was so happy to be able to help him and so many others on that day and moving forward. Over the next years, I met many more veterans, soldiers, and civilians, each with their own personal struggle. No matter what demons they were battling, I knew that art could provide help and solace.

> *"Laura came to my life like a guardian angel when I was deep down in a 'no-way-out' situation. With all her contagious positive attitude, she put me back on track. Life is not easy, and no one better than her knows it, but it's almost impossible to escape her energy. Her desire to live and see people happy around her is extremely motivating. She is all-giving because she has an unlimited source which is GOD himself. He sent her to earth to help those in need. That, in a few words, is how I can describe Laura."*
>
> *—Josignacio, Artist*
> *Sunny Isles, FL*

After listening to those with PTSD, I realized that I could identify with almost everything and the terror that they were experiencing because I experienced it myself. In my freshman year of high school I had been the victim sexual assault

twice by the same two male students in the hallway. After that I was given a mild tranquilizer, Librium. This created uncertainty and fear. Eight years later, in 1982, I was raped by two men in Bergen County. I did not report it. Instead, my mother took me to my psychiatrist and who convinced my mother that I was "manic" and making the story up for attention. From that point on, I buried the incident in the back of my mind. But then, I began waking up in the middle of the night, gasping for air, terrified: This, I now recognized, was PTSD.

I had been diagnosed as bipolar, but as I started working with the veterans I realized more and more that I had never addressed the trauma in my own life. Some of it may seem small, like the time I was playing at the playground with my best friend Jennifer near the handball wall. We were giggling, and acting like little girls when a young man playing handball turned, grabbed a rock, and threw it at me. It split my forehead open, and he ran. We lied and told our mothers that I fell. Some of the trauma was more serious, like the bullying at the park I often endured when we moved to New Jersey. And then, of course, there were the rapes.

Finally, the flashbacks and terrors I often experienced made sense. I had repressed something that had really happened to me, and thus was terrified by it. I was fortunate enough to have a friend who was retired law enforcement, work with me and refer me to books and other resources. The link of realizing I was suffering from PTSD and finding the language to speak about it and models to deal with it made it even more important to me to utilize art as a vehicle to help veterans.

Now, my art shows included my art, children's art, art of those in old age homes, the art of those suffering from mental and physical illness, and veterans' art, too. As always, all the proceeds go back to the individuals or organizations of aid and charity.

We were all helping one another and furthering the circle of help onward.

"Born from a passion for 'sharing the health,' the Caring Canvas™ gifts original works created by inspiration and hope to hospitals, group homes, safe houses, low-income housing and family shelters to promote awareness and healing."

—Laura Brunetti

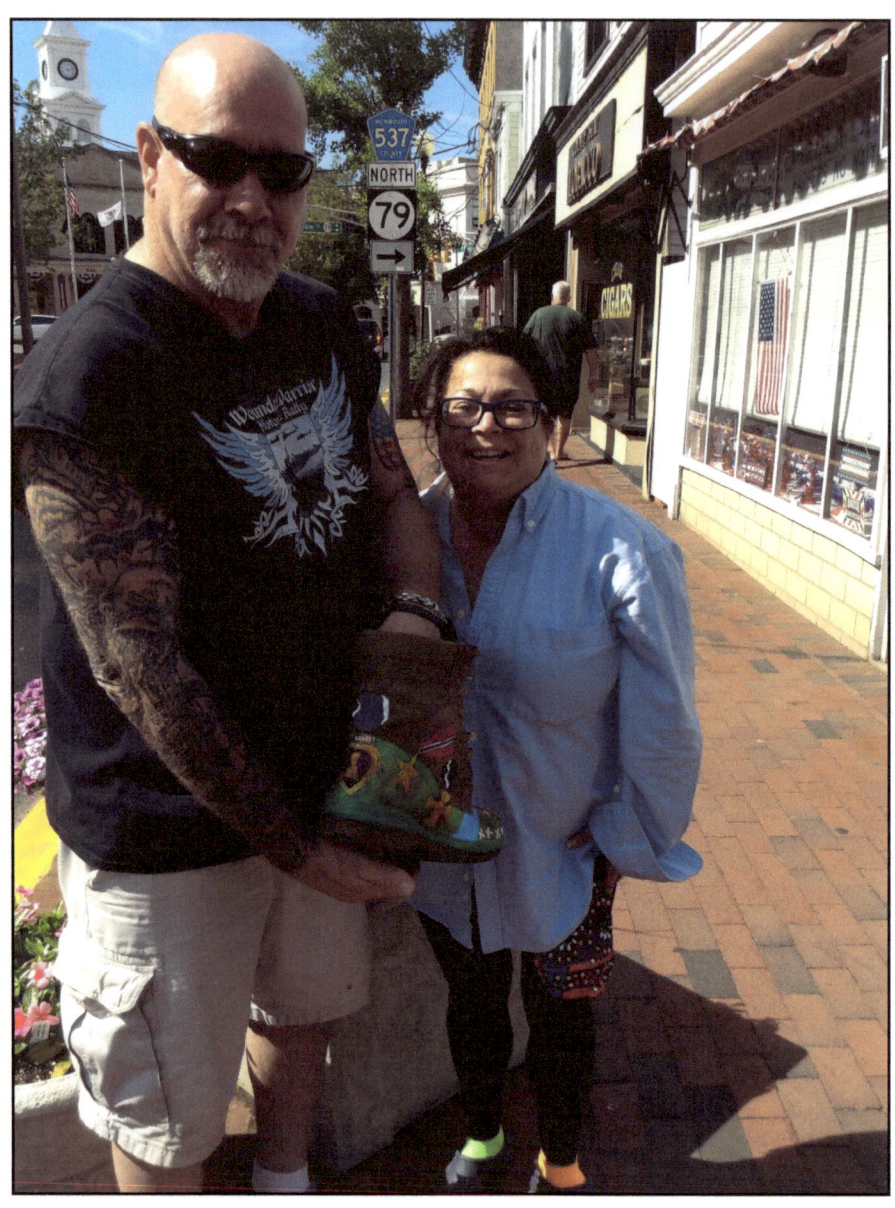

Laura Brunetti and Marine Veteran Wally Zuber, who created our mascot for Boots on American Soil—The Creative Force.

5
BEHIND THE MASK OF MENTAL ILLNESS

"You are a bright, shining beacon of kindness and generosity. You enrich our community immeasurably."

—*Ginger Mulligan,*
Retired President
The Mental Health Association
Monmouth County, NJ

The stigma of mental illness is real. This is why it was important for me to open up to those I served about my own mental illness. This is why I am never embarrassed to be open about how there is another possible Laura out there, one who didn't have loving parents, or good doctors, or faith. I tell people to always remember that everyone who commits suicide is not necessarily severely depressed. They may just needed a small glimmer of hope and help. Unfortunately, most people have the I-don't-want-to-get-involved attitude.

I get INVOLVED!!!!!!!!!!

I even have intervened online. I've looked up phone numbers and called people about their loved ones at two in the morning. I know what it's like to have the pounding in your head, to want to be dead. I remember the times I sat in my attic with a noose in my hand.

I didn't understand my faith then, but I do now.

Jesus Christ died for me and for mankind. By his blood on the cross, we are forgiven.

Faith is a great healer, the most important.

I tell everyone I work with that I am on a mission with God's permission.

By sharing my stories of mental illness, I am not only giving others hope; they help me, too. I would share my stories of the terror I had felt being ad-

mitted to a psychiatric hospital or to a psychiatric floor of a regular hospital. They knew I could relate to their terror, whatever it was. I told them how when I was in crisis, the hospital emergency room created more anxiety: I had to relate my medical history, without my psychiatrist there to help. The continuity was severed. It was a terrifying moment. They understood that I understood their anxiety at whatever challenges they were facing. All it took was a small story to let others knew that we were all in the same boat.

With bipolar disorder, the lows can drive you to suicide and the highs can create grandiose thinking. For example, you might think that you can beat a train or that you have special powers. Your judgment is off. The illness, if not treated properly, can become a cascading series of bad decisions. I was blessed that I didn't have a problem with drugs or alcohol, but I feel for those who do. It's just another manifestation of the hurt and pain that we all experience.

Since the early 1980s, I believe that God has sent people to me so that I can listen to them and guide them. He has also sent people to guide and bless me. I remember one late night when I working on a fundraising journal. It was a Saturday. These were the days of no cell phones or internet. The phone rang. It was a worker I knew from the print shop.

I said, "Oh, hi, Jay. How are you?"

He said, "I have a gun in my mouth."

His girlfriend had broken up with him, and he was in distress. I knew I had to keep him on the phone. There were no other phones or options. I didn't think, I just spoke as I had done many times before.

Jay had a change of heart or maybe he knew that I would be, through God, a saving heart who could hear him out. I have attempted suicide and been plagued at other times with the strongest thoughts and plans, so I could relate to Jay's state of mind. It was always the thought of my mother and family that made me reconsider.

My parents had always loved me unconditionally, which was priceless. They were kind people, always, and I didn't want to hurt them. When I was an adult, just starting out in life, they went one day to see my great-grandfather's church. They were surprised to see that his picture was still displayed there. They came home and told me about the free food offered at the church on Wednesdays for those in need. At that moment, something clicked in my mind. I, too, could make an impact. It was in my blood. It was my calling.

Helping others gave me purpose. God did have a purpose for me.

Through the many masks I wore to corral the pain from trauma, depression, and mental illness, I finally, through faith, learned that the real shame would be in not sharing my struggle with mental illness with others. I learned to eradicate the shame, forgive the blame, and take the path of preaching how, through the grace of the Lord Jesus Christ, I had been mended. God was my seamstress of the heart. I could offer that to others.

All it takes is love and understanding.

During several visits when my father was in assisted living, suffering from dementia, I was able to participate in what I coined Mime Mask Memory. In the assisted living setting, you become like family with the table-mates of your loved ones. Those whose loved ones lived with my father were well-informed about The Caring Canvas™ and the mission I was on and were thrilled to let their loved ones participate.

One day, I asked them to bring in a picture of their loved ones when they were small children. I blew the pictures up on cardstock and put them on wooden holders. The idea was to evoke the memory of loved ones at that time in their lives and have them recall as much as possible. My father and I did this together, while the others did the same with their loved ones.

When we were done, we would with mime or otherwise act out the memories they had told us of that time.

The next visit, I asked everyone to bring pictures of the person's loved ones who were no longer with us. I brought a picture of my mother who had passed. I made handheld masks of the pictures, which we all wore. My father, seeing me in the mask of my mother, said, "That's Mama!" Mama was what he had affectionately called my mother. It was a wonderful moment.

We were all so amazed and pleased at how animated and verbal our loved ones had become. All it took was art, compassion, and love.

The next visit, I brought in and played music from their era. My father instantly wanted to dance the way he and my mother had loved to do when they were younger. We danced, and his tablemates danced with their daughters and sons.

Another exercise we did was to encourage them to talk to themselves in a mirror. This also works with children. It was remarkable how we were able to get them to communicate when we created these creative outlets. These sorts

of simple activities were all that was needed to bring out the warmth, love, and laughter in those we loved. It didn't take much to help others, just the willingness to open our minds and our hearts to the possibility of connection.

I urge everyone, old or young, whole or broken, to reach out and do what they can for others. Do it with art, music, song, creativity, love, laughter, and hope. Do it openly, speaking of your own shortcomings and your own struggles and pain and regret. This reaching out and helping others, I have found, is a magical way to create a life worth living.

You, too, can give hope and joy to others, even if you think you have nothing to give.

Start with art, then go wherever the spirit takes you. Against all odds, trust your instinct, which is the Holy Spirit.

I promise, you'll be glad you tried.

> *"...someone who is concerned about other people's well-being and will go out of his or her way to help them — even if there is no chance of a reward. That person who helps others simply because it should or must be done, and because it is the right thing to do, is indeed without a doubt, a real superhero."*
>
> *—Stan Lee*

Acknowledgments

All who wander are not lost.

To my parents, who taught me through example that it is not what you have, but what you give that kindles the love in our hearts.

To my family near, far, and no longer with us. To those I never met and have only been told about, read about, and enjoyed the pictures of, thank you. It is a gift to identify with relatives, a comfort to live with a sense of belonging.

To Jesus Christ, my Lord and Savior, always there, especially at life's most difficult crossroads.

Special thanks to: Ed Johnson, former Mayor of Asbury Park, Visionary; Pat Schiavino, Gallery 629; Marat Fishman Art; D. Love Photography, Asbury Park; AP Transportation Center Staff; Be Scene Photography; Matt Denton; Roger Loco, Lobo, Apache Actor; Michael DeLaForce; Publisher-Like Magazine-Photographer; Kathleen Turner; The Caring Canvas- A. Neff King Visionary; Van Agens, The Caring Canvas; Courtney McKnight, The Caring Canvas and her cousins; Lauren Buffa, The Caring Canvas; Jack Buffa; Cordelia Donavan, The Caring Canvas; Brittany Hoff; Susan Belfer, cofounder The Caring Canvas; Eva and David Belfer.

And to all those I have not mentioned my prayers of gratitude are with you all.

Message in a Bottle

About the Author

Laura Brunetti has spent 20 years volunteering on the foundation board for the Mental Health Association of Monmouth County. She is also an artist, gallery curator, and has various permanent collections including the Brownstone Experience, East Village New York and the Ramapo Ridge Psychiatric Hospital, Wyckoff, New Jersey.

www.ingramcontent.com/pod-product-compliance
Lightning Source LLC
Chambersburg PA
CBHW041116180526
45172CB00001B/281